TOULOUSE-LAUTREC

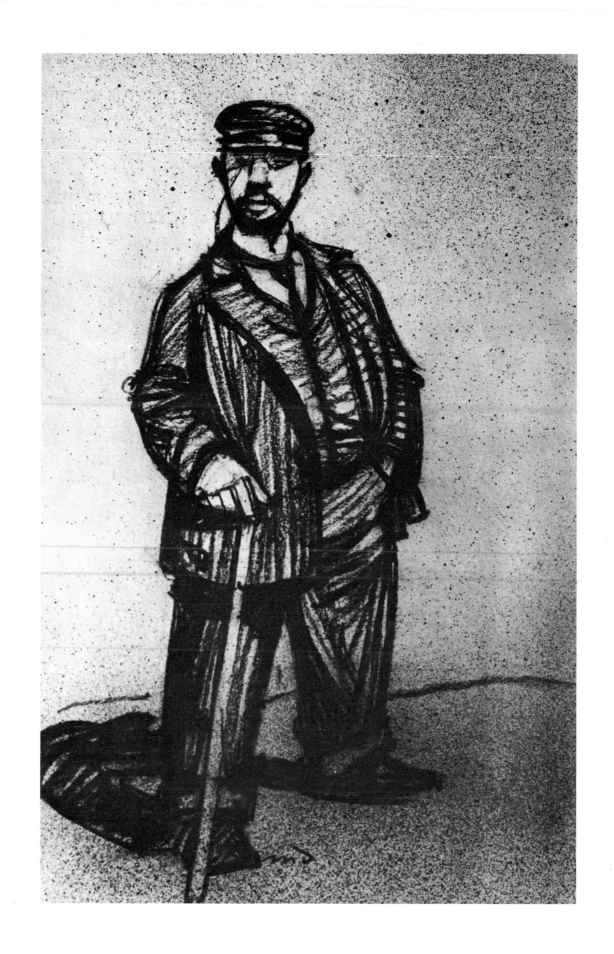

TOULOUSE-LAUTREC

John Loftus

Professor of Art
Hobart and William Smith Colleges

McGRAW-HILL BOOK COMPANY · NEW YORK · LONDON · TORONTO · SYDNEY

Cover picture, *La Goulue and Valentin*, lithograph, Musée Toulouse-Lautrec, Albi

COMMENTARY ON THE SLIDES

Henri-Marie-Raymond de Toulouse-Lautrec Monfa, descendant of the counts of Lautrec and the viscounts of Toulouse, could trace his ancestry to the time of Charlemagne. An aristocrat and a bohemian, he spent much of his mature life in the company of sportsmen, actors, dancers, impresarios, pimps, prostitutes, and artists. Lautrec's interesting and paradoxical character, the tawdry glamour of his environment, and his imprudent way of life have been the subject of a Hollywood extravaganza, a historical novel, and a large number of biographies. Though considerable space has been devoted to the details of his life, even the critical books and articles often neglect specific reference to his dimensions as an artist and his relationships with and influence on other artists. Yet this bohemian-aristocrat, grotesque charmer, profligate devoted son, this rake and faithful friend, tragic buffoon, draftsman-painter, realist of an unreal world is an artist of great interest and significance.

Lautrec was born in Albi in southern France on November 24, 1864 at 14 Rue de l'Ecole Marge, since renamed Rue Henri de Toulouse-Lautrec. His father Alphonse, the last of an ancient noble family to be serious about horses and falconry, was representative of a declining aristocracy in a period of social revolution. Famous for his eccentricities and his love of masquerade, he would sometimes appear in the costume of a Scottish Highlander, a Canadian trapper, or a Cossack, and his behavior frequently matched his costume. Henri's mother, Adèle Tapié de Céleyran, was a provincial bourgeoise, a rather conventional and unassuming woman who had little in common with the flamboyant Alphonse.

Brought up in wealth and comfort, Lautrec had the normal expectations of continuing the traditional life of ease, idleness, and sport which were the aristocracy's defense against the encroachments of the middle-class world. However, this prospect was changed by a congenital defect and two accidents fifteen months apart which left the young Lautrec with two broken legs requiring many months of convalescence. Drawing was the one activity he could continue to pursue during the painful months of healing and adjustment. By the time he was sixteen it was evident that his legs would not develop properly and, although the rest of his growth was normal, Lautrec attained a height of only four and a half feet.

Frontispiece.
Maxime Dethomas (1867-1929)
Portrait of Toulouse-Lautrec
charcoal drawing
19¼″ x 15⅓″
Musée Toulouse-Lautrec, Albi

[Facing this page]
Detail of Figure 8

5

Many writers have described the mature Lautrec as terribly deformed, even monstrous. Lautrec's sardonic references to himself, and the chanteuse Yvette Guilbert's description of him perhaps have helped promote the legend of ugliness. Yvette Guilbert, who figures so prominently in Lautrec's work and with whom he was on friendly terms for many years, always felt Lautrec had made her ugly in his many drawings of her. But her written description of him is a more biting caricature than any of his drawings of her. "A dark, huge head . . . a greasy oily skin . . . a nose big enough for two faces . . . a mouth that cuts across his face from cheek to cheek . . . thick flabby purple lips . . ."

From photographs Lautrec appears to have been quite normal from the waist up. His only deformity was his legs and they appear quite muscular in photographs which his friend and biographer Maurice Joyant took of him partially disrobed. His head was large for his stature, but not at all large for his chest and shoulders; his bright eyes and sensuous mouth in no way correspond to the descriptions of him as grotesquely ugly. The symbolist writer Jules Renard, whose *Histoires Naturelles* Lautrec illustrated, described him as a "tiny, little blacksmith wearing a pince-nez." The sympathetic portraits by Dethomas and Vuillard are perhaps closer to the truth (Frontispiece and Figure 1).

Whatever it did to his appearance, the crippling accidents of his childhood certainly changed Lautrec's life. Deprived of the hunting companion he had expected in his son, Alphonse detached himself further and further from his family, leaving Henri in the care of his doting mother, who encouraged him to develop his talents for drawing and painting. Amateur painting was a tradition in the family; Lautrec's great grandfather, his father, and his uncle all had painted, and the young Henri had been an avid sketcher from his early childhood.

At fourteen, Lautrec began his formal artistic training with a friend of the family, René Princeteau, a painter of horses and sporting scenes. Although Princeteau's achievements as a painter were modest, he was a sympathetic and good-humored man, and an excellent teacher who corrected Lautrec's sketches and provided entrance into the studios of Jean-Louis Forain and John Lewis Brown, successful illustrators whom the young Lautrec admired. Three years later, in the spring of 1882, through the intervention of a family friend, Lautrec was enrolled in Léon Bonnat's class. Bonnat, a member of the Legion of Honor and a successful portrait painter, was strongly opposed to Impressionism and any other challenge to the classic tradition as expounded by the Académie Français, the official arbiter of taste. As a young student Henri struggled hard to please this dry academic master, with little success. Bonnat, perhaps sensing Lautrec's natural affiliation with the "moderns" whom he detested, was a harsh and discouraging teacher, but by this time Lautrec's character had been formed and his vocation decided. Fernand Cormon, in whose studio Henri enrolled in 1883, was a successful academic painter and a permissive and encouraging teacher. Lautrec, with characteristic perversity, preferred the strict Bonnat. However, in Cormon's studio he became acquainted with Emile Bernard and Vincent van Gogh and made two life-long friends, the painters Louis Anquetin and François Gauzi. In the con-

Figure 1.
Edouard Vuillard (1868-1940)
Portrait of Toulouse-Lautrec
(1898), oil, 10" x 9"
Musée Toulouse-Lautrec, Albi

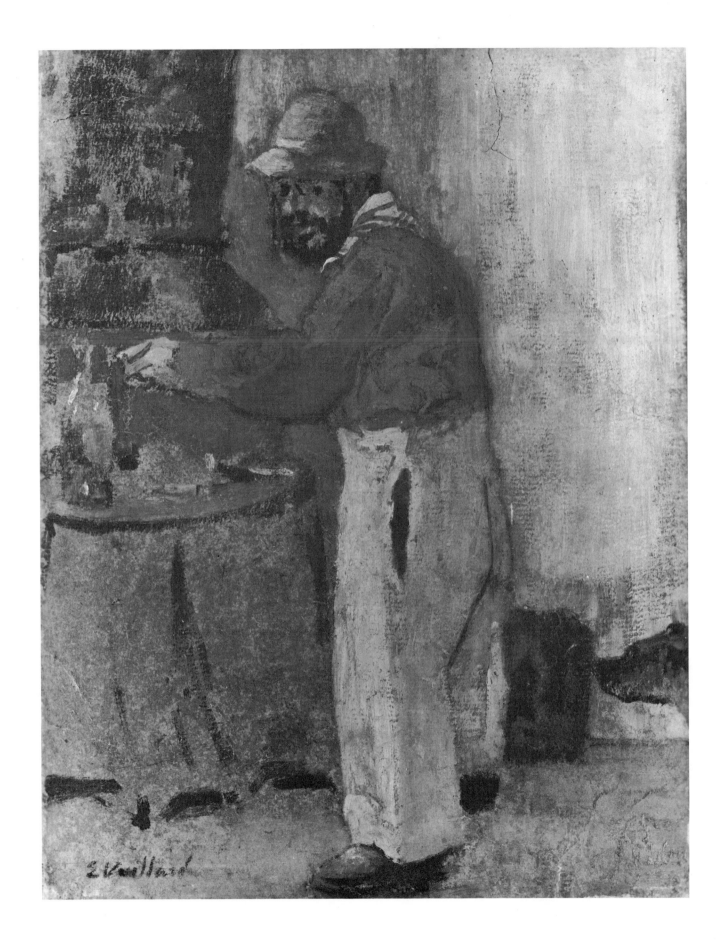

genial relaxed atmosphere of Cormon's studio many of the students openly admitted their admiration for Impressionism, and Van Gogh and Bernard in particular worked from ideas clearly antagonistic to academic procedures. To see how quickly Lautrec gravitated to the side of the radicals and adopted the Impressionist technique one need only to look at the portrait of his mother painted in 1883 (Slide 2) which uses the shimmering rainbow palette of Renoir.

For two years Lautrec lived with his mother in an elegant residential section of Paris and went daily to Cormon's studio. In 1885, when he was twenty-one, he moved in with his friends René Grenier and his wife Lily in Montmartre in order to be nearer his work and escape the somewhat oppressive atmosphere of his mother's house, although they continued to be on good terms and regularly lunched together. At this point, however, his friends and his new environment became the dominant influences on his life and his development as an artist.

That Lautrec gravitated from the milieu of a declining aristocracy to that of an intellectual bohemia—the world of artists, cafes, cabarets, and studios of the vanguard painters—is consistent and understandable, for on both levels he found a similar exclusiveness, disregard for money, and a tendency to view life as a charade. His aristocratic beginnings, his bohemian surroundings, and his personal misfortunes combined to give Lautrec a very acute awareness of the absurdity of life, and this sense of the absurd runs through much of his art. His background, his environment, and the contradictions of his character form the fabric of his work. The rounds of the cafes and cabarets were a nightly ritual with Lautrec and his entourage. Yet, after many all night sessions, he would go directly to his printers to spend the morning working on a lithograph stone.

Lautrec had a great capacity for love and friendship. He was befriended and protected by a giant, self-assertive fellow student, Louis Anquetin. The friendship and devotion of his biographer Maurice Joyant is well known. His cousin, Gabriel Tapié de Céleyran, was his constant companion after his arrival in Paris in 1891. With an independent income, Lautrec did not have to earn his living from his work and painted only what interested him; his portraits are a gallery of friends and associates. Despite his charm, vivacity, intensity, and ebullience, Lautrec was not altogether an easy friend. He dominated and bullied his faithful cousin Tapié de Céleyran who towered over him physically. His wit was frequently vicious even to his friends, and his feelings of inadequacy often caused him to be rude and abrupt.

On balance, Lautrec, despite his problematic character, must have been an interesting and entertaining friend. He has left us lithographed menus and invitations to many parties and dinners given by himself and his friends. The menus are of elaborate meals and the drawings are high-spirited and playful. His cooking and drink mixing and love of masquerade made him an excellent host. Lautrec was master of ceremonies and bartender at a party given by Alexander Natanson, publisher with his brothers of *La Revue Blanche,* the leading intellectual and artistic periodical of the 1890s. Lautrec's fantastic cocktails

Figure 2.
Jules Chéret (1836-1932)
*Pantomimes lumineuses
au Musée Grévin*
(1892), color lithograph
Musée Chéret, Nice

and condiments laid low about three hundred of the guests, among whom were Bonnard, Vuillard, Félix Fénéon, André Gide, Mallarmé, Alfred Jarry, and many others from the world of writers, artists, sports, and entertainment.

Lautrec's Paris, that is Montmartre from 1889 to 1901, was a setting readily understandable today. The coffee houses, discothèques, and little theatres of today provide essentially the same facilities for meeting, dancing, and entertainment that were afforded by the *cafés-concerts* like Le Divan Japonais, La Cigale, and Les Décadents and *les cabarets artistiques* like Aristide Bruant's Le Mirliton, Le Moulin Rouge, and Le Moulin de la Galette. (Lautrec made paintings, lithographs, and posters of these establishments.) Color lithography for theatre bills and advertising, introduced in France in 1866 by Jules Chéret (Figure 2), had great appeal to artists, and posters and poster shops were as widespread in Paris during the 1890s as they are today in New York, San Francisco, and London. There are even stylistic similarities in many of the posters of the two eras—they share a feeling for typography as design, a preference for bright flat pattern, and a taste for titillating decadence.

The entertainment in Montmartre featured political satire, sexual freedom, and irreverence. Aristide Bruant (Figure 3) shocked and insulted his customers like the sick comics of today: his cabaret, Le Mirliton, was advertised as "the rendezvous for those seeking to be abused." The quadrille offered the dancers opportunity for the same solo virtuosity that we see in many contemporary dances, though the rhythm and tempo are, of course, very different. Loïe Fuller's "electric dance," with veils and colored lights, was a sensation at the Folies Bergère (Slide 11). Today it would be billed as psychedelic.

Another thing the generations share is the move toward greater freedom in sex with fewer inhibitions about displays of nudity. Many people, then as now, aspired to nudity and sexual freedom, and though few reached it, those few were visible, enjoyed considerable notoriety, and added a definite character to the era. Lautrec portrayed prostitutes, lesbians, and male homosexuals in many of his paintings, and in those marvelous period photographs which fill the many biographies of Lautrec, the entertainers of the period are seen nude and half-nude. Sex is treated lightly, even playfully, in these photographs and Lautrec's handling of lesbian love is sympathetic and tender. This attitude may not be expressed as openly or be as widespread as the polymorphous perversity of our own times, but it certainly prefigures it.

Prosperity and unrest are also characteristic of both periods. France had recovered from the shock of the German invasion of 1870, investments were secure, and the stock market was booming. It was, however, an uneasy prosperity: the bombs and the assassinations of the anarchists shattered the facade of *la belle époque.* The first group of student anarchists was formed in Paris in 1890. Many artists and writers were drawn into this vortex: Camille Pissarro, Théophile Steinlen, Félix Vallotton, and Théo van Rysselberghe contributed to the anarchist periodical *Les Temps Nouveaux.* Lautrec's association with these artists and with anarchism was certainly peripheral, perhaps because of his antipathy to any kind of doctrine, but his haphazard style of life and his extreme individualism were manifestations

Figure 3.
Aristide Bruant on a Bicycle
(1892), oil on cardboard
11″ x 9½″
Musée Toulouse-Lautrec, Albi

sympathetic to the anarchists' cause. In any case, the trials and repressions of 1894 seriously hampered free expression. Student anarchy, bombings, assassination, middle-class smugness, and repressions—the modern parallels are too depressingly abundant. But perhaps more unfortunate is the fact that in the 1890s, as today, to certain segments of the population, the freedom and abandon of Lautrec's world were more disturbing than the bombings and assassinations by the anarchists. To an academic artist like Léon Bonnat, Lautrec was a more threatening figure than the anarchist assassin Ravachol. Bonnat's hostility toward his former student continued even after Lautrec's death. In 1905, Bonnat, as chairman of the superior council of museums, insisted (acting beyond his authority) that the government reject the proferred gift of Lautrec's portrait of Monsieur Delaporte, now in the Copenhagen Museum.

Lautrec's career unfolds in this complicated era which is at once his subject and his first audience. He exhibited for the first time in 1886 at the Salon des Arts Incohérents under the anagram pseudonym of Toulau-Segroeg, which he adopted because of family objections to the use of its name in so lowly a profession, a name now more famous for its association with the painter of *Fat Maria* than for its descent from King Louis the Fat. When he exhibited again in Brussels with the young revolutionaries, the Groupe des XX, in 1888, it was under his own name. He continued to exhibit in Brussels with the Groupe des XX until 1896. In 1887 he was included in the Salon des Indépendants where his work was seen with that of Seurat, Signac, and Gauguin and others of the new Post-Impressionist generation of French artists. In October of 1891 his poster *The Moulin Rouge* appeared all over Paris, making Lautrec and the singer-dancer-entertainer La Goulue famous at one stroke. He continued to design posters until 1899. His work contributed to the acclaim of Aristide Bruant, and Jane Avril's initial success dates from Lautrec's first poster of her (Figure 4).

During the nineties, Lautrec published several series of lithographs, including *Café Concert* (1893), *Yvette Guilbert* (1894) (Slide 16), and *Elles* (1896). These lithographs and illustrations, which he made for periodicals like *La Revue Blanche* from 1895 to 1897, and a number of books, including Clémenceau's *Au Pied du Sinai* (1898) and Jules Renard's *Histoires Naturelles* (1899), were the chief source of his fame as an artist, and toward the end of the decade became as important a source of income as the money he received from his family.

In 1899 after a decade of consistent productivity, Lautrec's output declined. He was hospitalized in the spring of 1899, recovered for a short period in which he produced a few works, and died on September 9, 1901, a victim of the dissolute environment which had been the material of his art. Like his contemporaries Van Gogh and Gauguin, his life and his art were intertwined and like them, he paid for his art with the coin of his suffering.

Many writers, following the example of Gerstle Mack's interesting biography, have divided Lautrec's work according to periods in which his interests focused on a particular subject. His early work, until 1888, consisted mostly of portraits; his interests in cabarets

Figure 4.
Jane Avril at the Jardin de Paris
(1893), color lithograph
50¼" x 37⅓",
Musée Toulouse-Lautrec, Albi

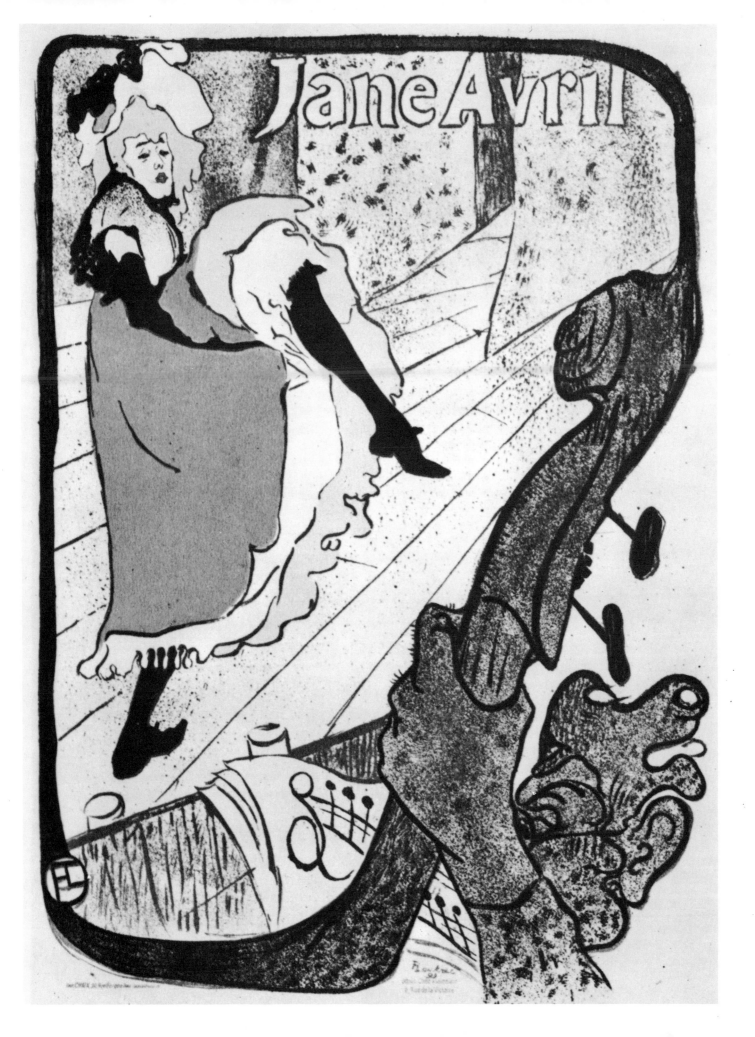

and *cafés-concerts* was strongest between 1889 and 1893; and from 1893 to 1896, much of his work revolved around prostitutes and their environment. However, such categorizing tends to give a somewhat distorted view, for throughout his life Lautrec made portraits of his family, his friends, and fellow artists; horses and sport appear in his earliest and last works; his preoccupation with the theater was a response to the same impulse which had attracted him to the cabarets and *cafés-concerts* and the circus. In short, Lautrec, continually attracted to all the phenomena of his environment, portrayed life as living theater and though his interest in one subject or another would wane and revive at different times, his attitude towards these subjects was fairly consistent. He painted horses and riders, cyclists, and dancers whose energy he absorbed through his eyes. He painted women in settings which made them remote. This is as true of the prostitutes as of the women like Lily Grenier and Yvette Guilbert whom he admired from a distance (Slides 4 and 16). Many of his portraits of male friends show them as actors in dramatic situations. Joyant he portrayed as a sailor, Guibert as a decadent. Lautrec is the stage manager of a brilliant, exciting, energetic environment which he enters through his eyes and manipulates through his work. The scene shifts from time to time and new players take the stage, but his absorption and control of this tumultuous activity remains constant, and the principal character of the drama is the director, Lautrec.

Theatricality was as much a part of Lautrec's life as it was of his art. Like his father he loved costume and fancy dress and many photographs show him elaborately costumed: an army private, an Apache, a Japanese, a woman, or a ship's captain. He was alternately droll, arch, or manic, responding to the role in which he had cast himself. Less self-absorbed than his father, Lautrec viewed the world as total theater and saw meaning in color and gesture; the angle of a top hat, the slouch of a shoulder, the arch of an eyebrow are significant in the development of the expressive and plastic quality of his work.

Nourished by the tradition of drawing and graphic art which begins with Goya, the strain of realism which cuts through most of nineteenth-century art, and the linear painting of Ingres and Degas, Lautrec, as both painter and draftsman, absorbs and transmits these main currents which appear with varying degrees of emphasis in most of his work. As voracious of other artists as Picasso, Lautrec also received stimulus from the mid-nineteenth century cartoonists Gavarni and Guys, as well as his contemporaries Steinlen and Forain. He took what he needed and his use of other artists cuts across all bounds of school or doctrine. But that signature character of his work that we recognize as Lautrec justifies his adaptations. Deeply interested in his own times, Lautrec interpreted his surroundings with techniques shared by his vanguard contemporaries. Not a conscious innovator like Cézanne, nor like Bonnard interested in updating Impressionism, he was, simply by being himself, a prophetic artist whose technical innovations and attitude toward his work prefigure important aspects of twentieth-century art.

It is Goya, Daumier, and Lautrec who provide the strongest threads in the tradition of drawing which continue to inspire today's artists—a style characterized by rapidity of

Figure 5.
Woman Putting on Her Stocking
(1894), oil on cardboard
23″ x 17″
Musée Toulouse-Lautrec, Albi

14

Figure 7.
Fantaisie Monsieur Guibert
(1900), lithograph, 10½″ x 9½″
Photograph courtesy New York Public Library

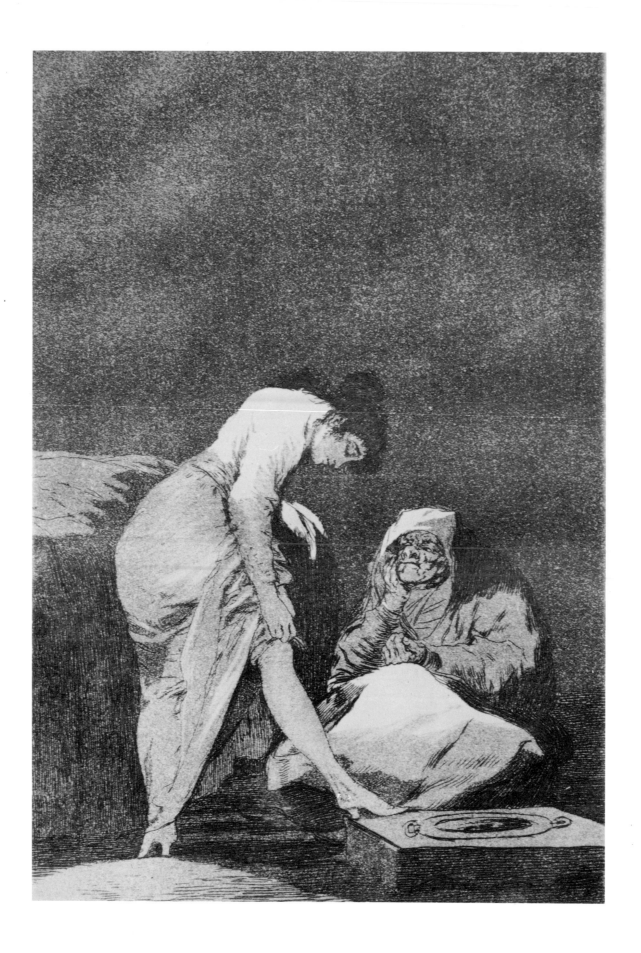

execution, an incisive line, and great strength of form achieved by an all-over control of compositional structure, which is counterpoint to the highly personal bravura quality of their work.

Lautrec's admiration for Goya is well known; he made a cover intended for an edition of Goya's *Disasters of War* and several writers have noted that he shared with Goya a quality of detached observation. In his observation of human folly Lautrec comes closer to the bemused Goya's *Caprichos* than to the bitter Goya of the *Disasters of War*. Lautrec's pastel drawing of a young girl pulling up her stocking (Figure 5) shares more with Goya's *Bien Tirada Esta* (Figure 6) than an interest in the subject of prostitution. Both show strong silhouettes, strong linear definition, and use pure white for brilliant highlights. The Lautrec is more forthright and less judgmental than the Goya. The opposition of age and youth and the theme of the sale of women is seen in several of Lautrec's works; the *Englishman at the Moulin Rouge* (Slide 10) is certainly the image of the out-of-town buyer, and Lautrec perversely makes the subject of his friend Maxime Dethomas (Slide 19) and the ladies at the masked ball of the opera look like the parlor of a brothel.

Lautrec was first introduced to brothels by Aristide Bruant and later frequented them in the company of the man called his dark angel, Maurice Guibert (Figure 7). Guibert, a champagne salesman and man about town (and considered a bad influence by Joyant and the Lautrec family), was a frequent companion of Lautrec and is seen in many of his paintings and drawings. During the years of 1892 to 1894 Lautrec spent as much as two weeks at a time as a resident of these establishments and, as some of his biographers have pointed out, these long visits were more useful for his work than for sexual gratification. His observations of the girls in these exotic quarters led to a series of lithographs, drawings, and about fifty paintings. Degas, Rops, and Guys had used this subject before him and Gustave Courbet had dealt with lesbian love in his *Les Dormeuses* of 1866, but no one approached the subject with the directness, simplicity, and tenderness which Lautrec displays in *Friends* (Figure 8). Courbet, in rendering this theme uncharacteristically reverted to a classical handling of the figures, a device of academic painters for purveying pornographic content. Lautrec, however, painted them with a casualness that moves the subject from the erotic and pornographic to the simply human.

Degas was the artist with the most profound affect on Lautrec, who regarded him with awe, a unique tribute from a man who usually considered the rest of the world with aristocratic disdain. He met Degas through the Dihau family, musicians who were on friendly terms with the master. Both painted several pictures of members of the family (Slide 7). When Lautrec made a joint exhibition with his friend Charles Maurin, a painter and engraver, Degas, arriving late at the exhibition, had some words of praise, a source of considerable satisfaction for Lautrec; but it must be added that he gave little support to the young artist, whose efforts moved in the direction of his own work.

Lautrec's awe and reverence for Degas did not deter him from using the techniques and compositional devices of the master that were useful to him. One of Degas' major

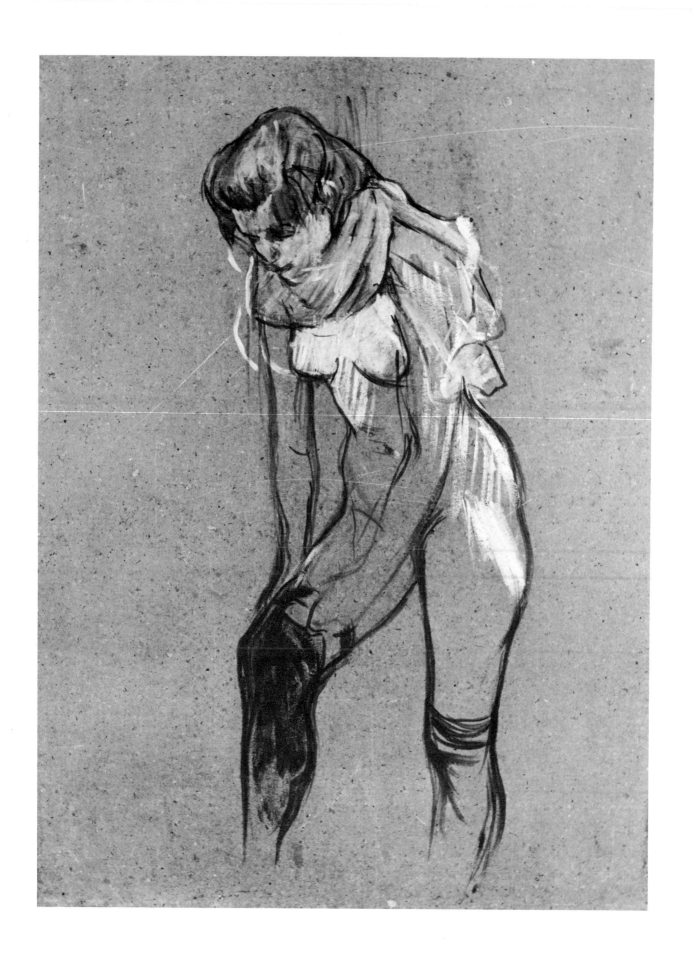

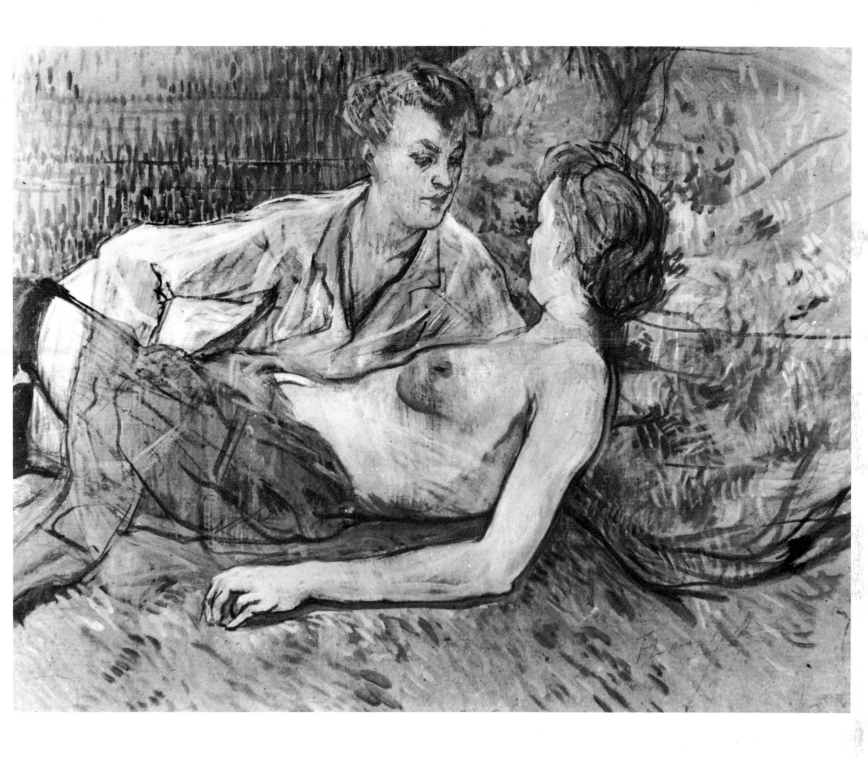

Figure 8.
The Two Friends (1895)
oil on cardboard, 25″ x 33″
Buhrle Collection, Zurich

achievements was his ability to synthesize line and color through the use of pastel and the colored line it produces. This permitted him to retain the drawing in the tradition of Ingres and yet to combine it with the heightened color of his contemporaries, the Impressionists. Lautrec, as a draftsman who wanted to be modern, faced the same problem. His solution was the use of thin oil paint on cardboard applied with single narrow strokes which result in an effect not unlike that of pastel, and permit the drawing and the effect of the color to mutually enhance one another. It should be noted also that Lautrec's early teacher Bonnat had been a great admirer of Ingres, and the young Lautrec had tried hard to meet Bonnat's standard of draftsmanship.

One can see in Degas' *Rehearsal* of 1877 a compositional device that was very useful to Lautrec (Figure 9). The large, empty horizontal plane to the left of the canvas which moves dramatically backwards is broken by a frieze-like grouping of figures which moves across the canvas, reinforced by the wall and interrupted by vertical French doors. The other vertical elements, spaced in careful opposition, are the standing figures and the winding stairs in the foreground. The tension between the vertical and horizontal elements provide a delicate and tenuous asymmetrical balance characteristic of the control of the skilled ballerina. Lautrec has used this schema in *The Salon* (Figure 10). The couch provides the backward horizontal thrust, the column and doors and the figures in the foreground are the coinciding vertical elements, the wall and figures in the background move across to limit the space. In the sketch for the poster *Moulin Rouge* (Figure 11), Lautrec has compressed this schema but has introduced the three abstract forms on the left, which work in the same way as Degas' spiral staircase. One can also see a variation of this device in *The Dance at the Moulin Rouge* (Slide 6) and in the poster of the *Troupe de Mlle. Eglantine* (Slide 17).

These devices of course were not original with Degas; they come from the influence of Japanese prints, which provided the example of asymmetrical compositions, and from contemporary photography, with its cut-off figures and spontaneous postures. Lautrec had made a number of paintings based on the work of his friend, the photographer Sescau. *The Last Crumbs,* for example, was based on a Sescau photograph. Comparison of this painting of 1891 (Figure 12) with Degas' *Absinthe* of 1876 (Figure 13) is more interesting for the differences it discloses than for its more obvious similarities. Degas chose his friend Marcellin Desboutin and the actress Ellen Andrée to masquerade as a dissolute couple. Lautrec chose his friend and fellow reveller Maurice Guibert and, in accordance with his usual preference, a beautiful red-haired model. Whatever their individual merits as paintings (and the Degas is certainly the more complete work), as images of decadence the Lautrec is the more convincing, perhaps because Lautrec's experience with this kind of life gave him some advantage over the somewhat prim Degas. Formally, the paintings are a generation apart; Degas has cleverly used the marble table tops, in the Japanese manner, to provide a balance for the two off-center figures, and at the same time has created a deep space to allow him to express the volumes of the figures and the bottles on the

Figure 9.
Edgar Degas (1834-1917)
The Rehearsal (c. 1877)
oil on canvas, 23″ x 33″
Glasgow Art Gallery and Museum
Burrell Collection

Figure 10.
The Salon at the Rue des Moulins
(1894), oil on canvas, 43″ x 47½″
Musée Toulouse-Lautrec, Albi

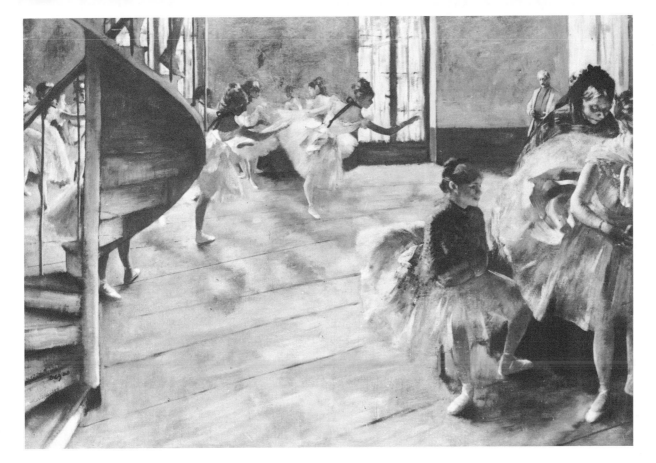

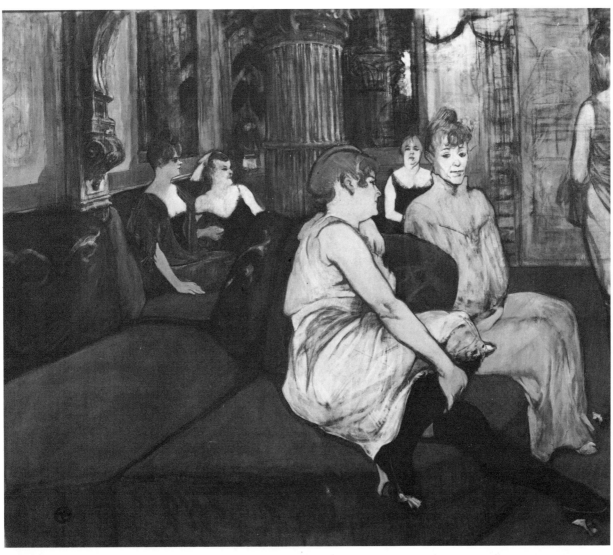

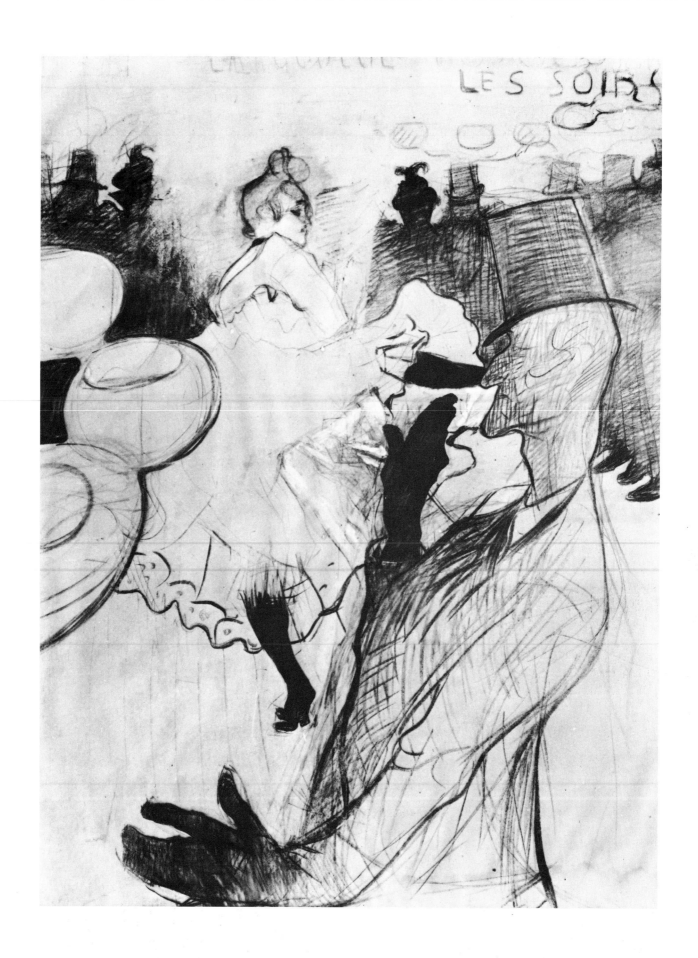

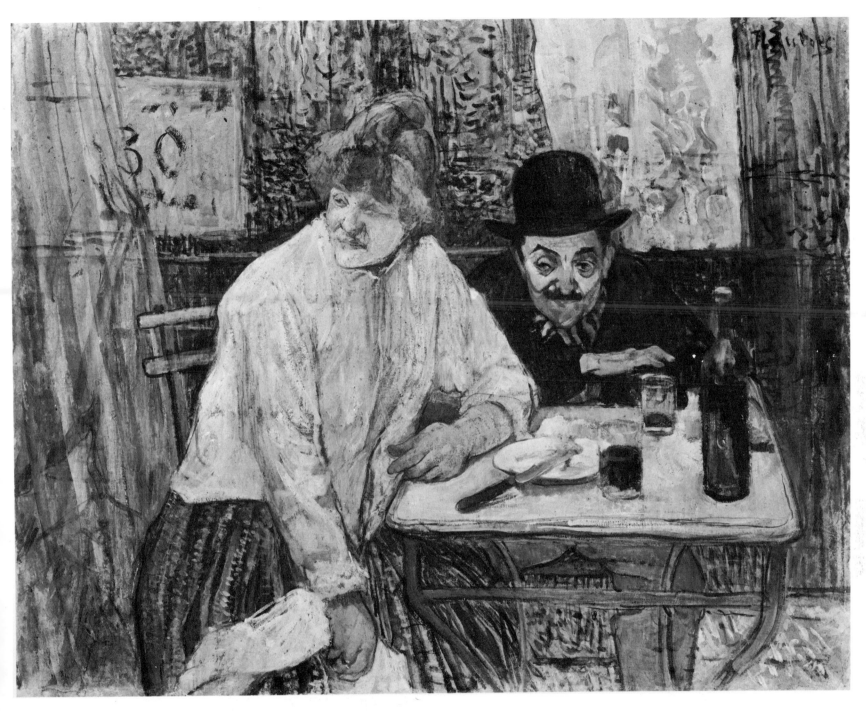

Figure 12.
The Last Crumbs (also known as *A La Mie*)
(1891), oil on cardboard, 21″ x 26¾″
Museum of Fine Arts, Boston
S. A. Denio and General Income, 1940

Figure 11.
The Moulin Rouge, La Goulue (1891)
colored drawing, 60½″ x 46¼″
Musée Toulouse-Lautrec, Albi

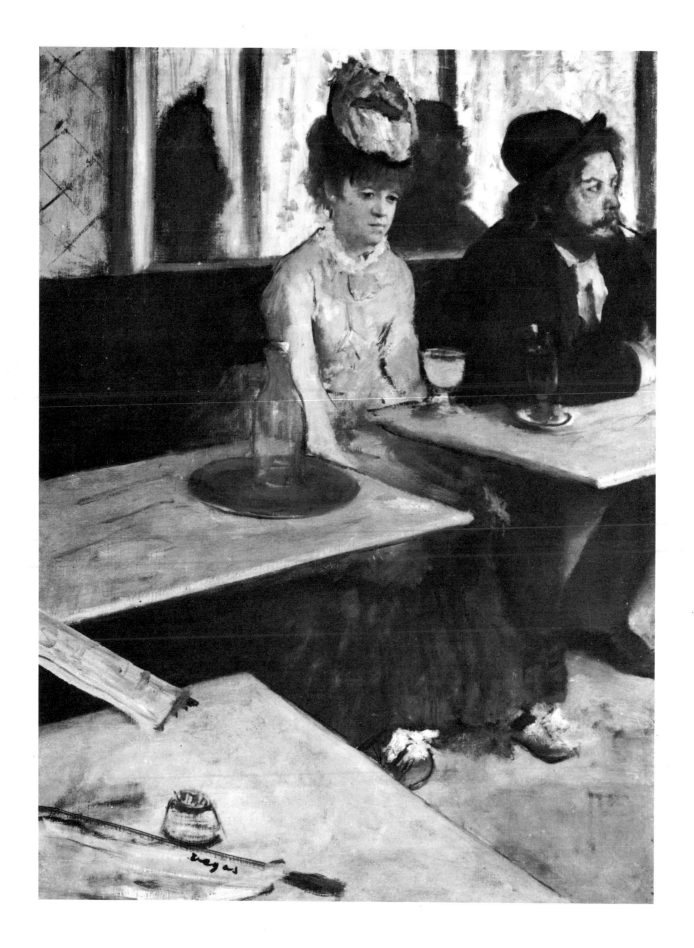

table more fully. Lautrec has preferred the shallow space and horizontal and vertical resolution of closely textured form, more in accord with the practice of his younger contemporaries Bonnard and Vuillard. The emphasis by Lautrec on flat silhouettes and overlapping planes points to further developments in the twentieth century; as the art historian Hans Tietze has observed, Degas' *Absinthe*, Lautrec's *The Last Crumbs*, and Picasso's etching *The Frugal Repast* (1904) show the involvement of three generations with the same theme.

Most writers on Lautrec have stressed his disdain for artistic theory; they have mistaken Lautrec's dislike of discussion of artistic theory for rejection of a theoretical approach to painting itself. It is true that Lautrec plunged directly into life, a wild and fantastic one at that, but as a painter and an artist he was a systematic and careful workman. As a young man of nineteen he had already mastered Impressionism, and like Seurat, Cézanne, and Van Gogh, moved beyond it. He absorbed the influence of Japanese art, contemporary photography, and Degas, and shared with Bonnard and Vuillard an interest in lithography and posters. (Lautrec's posters are enjoying a new popularity. Large editions have been reproduced and have earned him a new generation of admirers.) Many of his subjects were similar to those of Forain and Steinlen, but Steinlen's drawings, though quite close to Lautrec's, lack the rigorousness of pictorial structure that is one of Lautrec's great strengths. Lautrec utilized in his work the artistic ideas of his precursors and contemporaries with a tough-minded professionalism that would not permit anyone else's ideas to stand in the way of his particular expression.

Lautrec's work was much admired by many of his contemporaries. By the early 1890s his posters and illustrations had made him a well-known figure, and he had been represented in a number of important exhibitions. His works were hung in Bruant's Le Mirliton and in Le Moulin Rouge. The *Cirque Fernando* (Figure 14), in the foyer of the Moulin Rouge, was seen there by Georges Seurat, whose painting, *The Circus*, adapts the arabesque and dynamic qualities of Lautrec's composition. Douglas Cooper, a discerning English critic, has pointed out quite correctly that Seurat brings to his work an already complete "pictorial science." It is more finished than Lautrec's, as one would expect from the last work of a highly polished artist compared to the first group composition of a developing one. However, if one looks at Seurat's sketch for *The Circus* (Figure 15), it is apparent that its looser formulation and greater dynamism is much closer to Lautrec's work than the somewhat dry, highly controlled finished painting of the subject. The compressed space, the dynamism, and the dramatic tension of Lautrec's treatment of this theme can be seen in E. L. Kirchner's *Circus Rider* of 1913 (Figure 16), which follows quite closely the compositional schema of *At the Nouveau Cirque* (Slide 8). Kirchner also did a series of cafe scenes with dancers and entertainers which are prefigured in Lautrec's paintings. Lautrec is a seminal artist for twentieth-century Expressionism, while the influence of Seurat's method led to the academic dryness of Théo van Rysselberghe and other minor Pointillists.

Figure 13.
Edgar Degas (1834-1917)
Absinthe (1876)
oil on canvas, 37″ x 27½″
Louvre, Paris

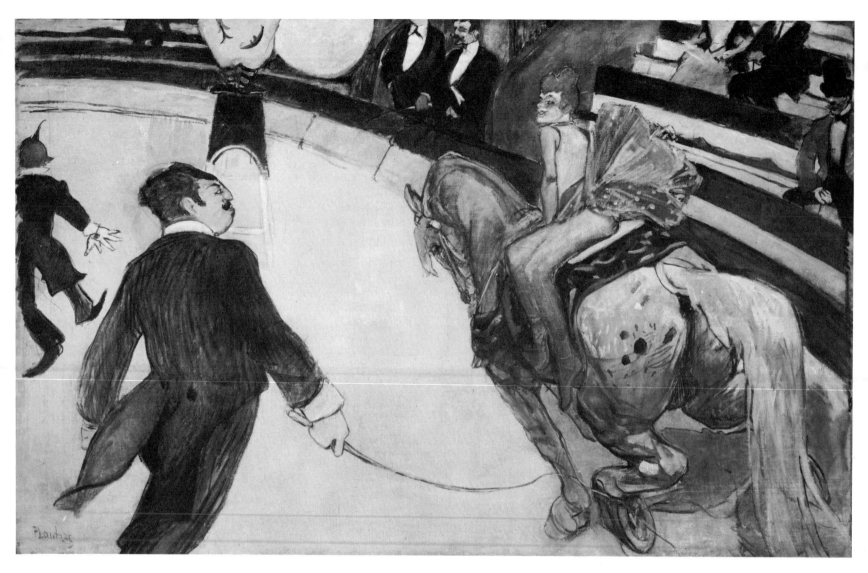

Figure 14.
In the Cirque Fernando: The Ringmaster
(1888), oil on canvas, 39½″ x 63½″
The Art Institute of Chicago
The Joseph Winterbotham Collection

Figure 15.
Georges Seurat (1859-1891)
The Circus (1891)
drawing, 21¾″ x 18¼″
Jeu de Paume, Louvre, Paris

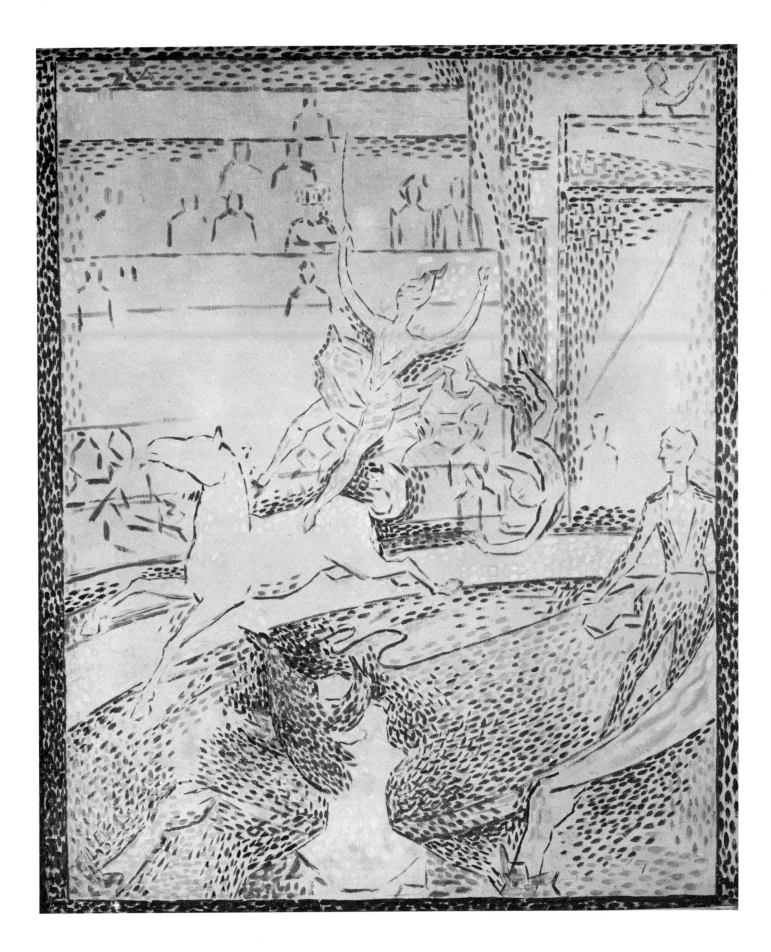

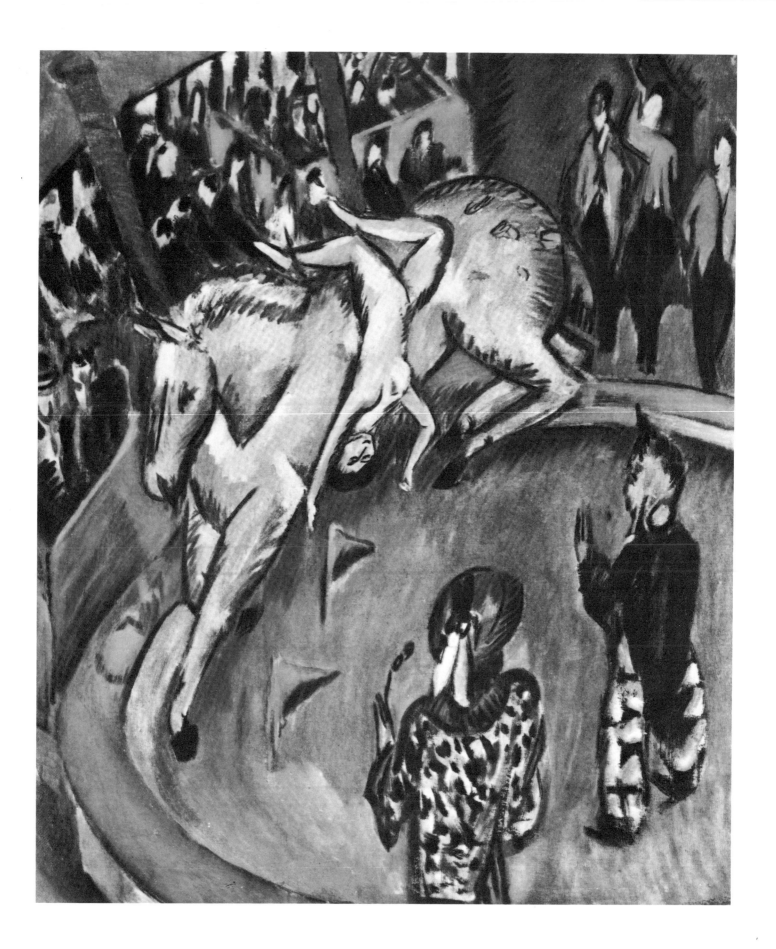

Georges Rouault (1871-1958) is another artist whose early work is anticipated by Lautrec. A very interesting development can be observed by comparing Lautrec's *Nude Standing Before a Mirror* (Figure 17) with Rouault's *Prostitute Before a Mirror* (Figure 18). The standing nude is solidly painted in the compressed interior space which is characteristic of much painting in the 1890s, but the mirror image has the abstract and expressionistic character that we see in Rouault's seated figure. In turn, the crude mirror image in Rouault's painting anticipates the painting of women by later Expressionist artists like Willem de Kooning, Karel Appel, and Jean Dubuffet.

Lautrec was a strong influence on Picasso's work of 1901 and 1902. During this period, Picasso painted a number of cafe scenes which illustrate that *fin de siècle* decadence characteristic of Lautrec's rendering of the same subjects. It was Lautrec's Paris that captured the imagination of this young artist and the *Moulin de la Galette* was the first painting Picasso made on arriving in Paris. His *Jardin Paris,* a design for a poster (Figure 19), is a paraphrase of the *Troupe de Mlle. Eglantine* (Slide 17). Although the four figures are in the opposite receding relationship, this sketch by Picasso if printed would have had the figures in the same relationship as those of Lautrec's poster. Both works have a similar receding ground plane although Picasso had not yet attained the compositional rigor and clarity of Lautrec's work. In *Jardin Paris* the figures are subsumed in the background and the horizontal foreground plane lacks the dramatic contrast one can see in the Lautrec. Its general effect is closer to the posters of Jules Chéret (Figure 2), with their soft late Rococo allure, than to the brisk modernity of Lautrec.

Up to this point we have seen Lautrec in the pictorial flux of stylistic development. He has a crucial, pivotal position as an intermediary between the nineteenth and twentieth centuries, for his work stands between realism and expressionism. His use of Japanese color, flatness of tone, and his drawing, culminating a nineteenth-century tradition, are important sources for modern artists. In all these areas of influence he is not unique; those features of twentieth-century art were transmitted by a number of other artists, but Lautrec does share with them the credit or the burden of modern development.

There is one aspect of Lautrec's work, however, where he is truly in advance of his contemporaries, and that is in the synthetic and arbitrary quality of his work. More than any other artist in his generation, he saw clearly the difference between pictorial organization, that is the composition and organization of a projected image, and visual structure, which is the organization of a received image. The projected image is expressive and an act of the mind; the received image is a source of information and dependent on the eye. Maurice Denis formulated the abstract nature of pictorial organization, but never completely realized it in his work, which is overburdened by content. Gauguin comes closer, but his structure is frequently vitiated by his romanticism and exotic décor. From *Au Cirque Fernando* onward, Lautrec's works are a fabrication of cut-off figures, compressed space and spatial incongruities, and hieratic arrangement of figures in a synthetic *mise en scène,* all for the purpose of a purely pictorial drama.

Figure 16.
E. L. Kirchner (1880-1938)
The Circus Rider (1912)
oil on canvas
Formerly
Stuttgarter Kunstkabinett
now Collection
Roman Norbert Ketterer
Switzerland.

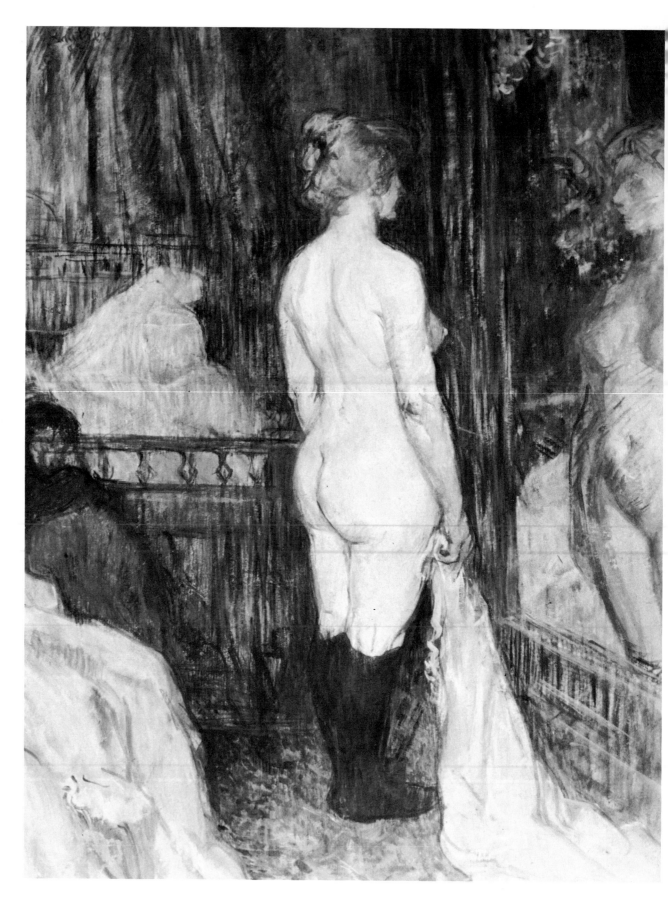

Figure 17.
Nude Standing Before a Mirror
(1897), oil on cardboard
24½″ x 18¾″
Collection of
Mrs. Enid A. Haupt, New York

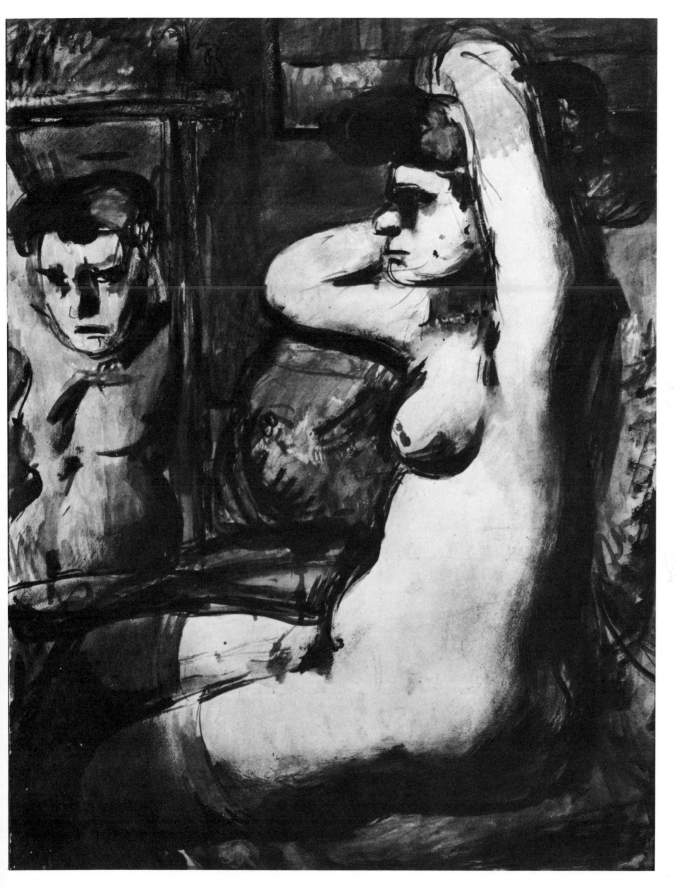

Figure 18.
Georges Rouault (1871-1958)
Prostitute Before a Mirror
(1906)
watercolor, 28½″ x 21¾″
Musée d'Art Moderne, Paris

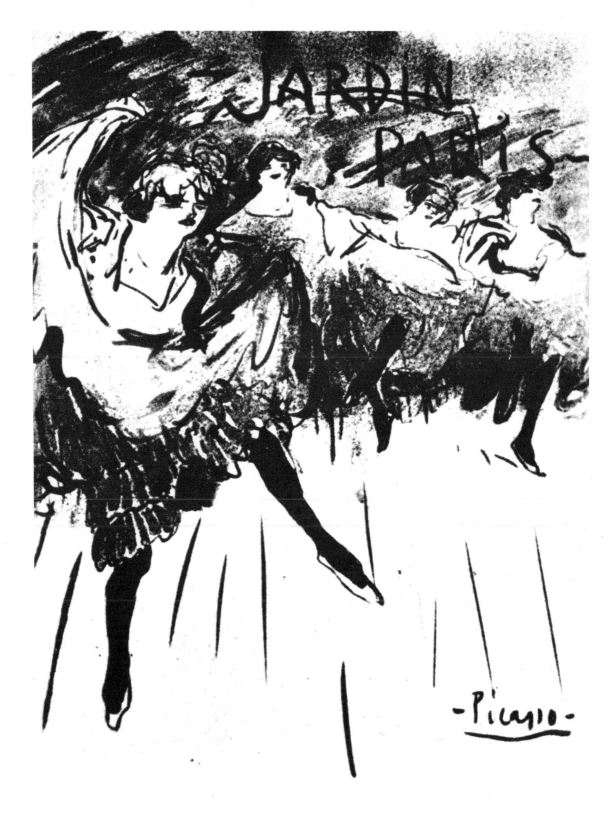

Figure 19.
Pablo Picasso (1881-), *Jardin Paris* (1901)
watercolor, 25″ x 19⅓″
Private Collection, New York

A number of modern movements can claim Lautrec as a precursor. His use of rhythmic arabesque contributed to the development of Art Nouveau, and although he was not alone in this, his posters were an immediate, visible source. The use of broad, flat colors, which he adopted from the Japanese, certainly anticipates Fauvism. Louis Valtat (1869-1952), a Fauve artist, admired Lautrec enough to paint a paraphrase of *The Dance at the Moulin Rouge.* Critics have pointed out the planar element in Lautrec's work and related it to Cubism. Lautrec's concern with the portrayal of dramatic action was an early example for the Futurists; he painted cyclists and dancers in action long before Severini and Boccioni. Even Dada can claim Lautrec as a protoparaphysician. He did help design sets for Alfred Jarry's "Ubu," and the fly sheet *Nib,* which was published as a supplement to *La Revue Blanche* in 1895, and edited by Lautrec and Tristan Bernard, was certainly Dadaesque. The word "nib" like "dada" was a nonsense word and the publication's contents was mostly nonsense and irreverence.

Later movements in twentieth century art also look back to Lautrec for that historic confirmation which has become so important for every new development. His use of the accidental effects of spattering in his lithographs (craquie) is a technical discovery used for very different ends by abstract surrealists and painters as different as Hans Hofmann (1880-1966) and Jackson Pollock (1912-1956). His lithograph of Loïe Fuller has been cited as a contribution to modern abstraction, though it is perhaps more important as an early attempt toward kinetic art. Lautrec, like many artists today, wanted to transcend the difference between fine and commercial art (see comments on *Reine de Joie,* Slide 9).

The above paragraphs are not intended to prove that Lautrec invented the twentieth century. Certainly Lautrec was not looking, like Stendhal, for a future audience which would appreciate him. His approach to his work was down to earth and completely absorbed in the present. Paradoxically, his absorption in the present is one of the characteristics which made him a prophetic artist.

Lautrec has not become a monument like Cézanne, Gauguin, or Van Gogh; his art does not point to absolutes of form, color, or feeling, but rather to a humanizing of these elements, that is, making them viable to everyday human experience. He does not provide following generations with a body of doctrine or a pure example of action. He is a diverse, experimental, highly intelligent, undoctrinaire artist, and by virtue of these characteristics his work has been most interesting and continually satisfying to modern sensibilities and especially pertinent to succeeding generations of artists.

COMMENTARY ON THE SLIDES

1: COUNT DE TOULOUSE-LAUTREC DRIVING THE MAIL COACH TO NICE
(1881), oil on canvas, 16½″ x 20½″, Musée du Petit Palais, Paris

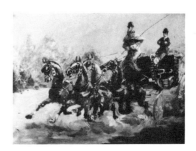

In this early work Lautrec's father is shown driving a lively team with the great gusto and spirit he brought to all his outdoor activities, and Lautrec has caught his father's exuberance. Done under the influence of his first teacher, Princeteau, it has, nevertheless, the *plein air* brilliance of Impressionism. Even more surprising is the marvelous painterly richness of the sketch. Lautrec's brushwork is both free and precise, with the color—the whites and reds in particular—laid on freshly and directly without the scumbling and murkiness of his later work.

Lautrec's father appears in a number of other paintings, such as *The Dance at the Moulin Rouge* and *M. Boileau*. Their relationship was extremely casual and the references to Alphonse in the young Lautrec's paintings are somewhat sardonic. However, despite their seemingly casual relations, Alphonse's grief at his son's death was very great. In a letter to Maurice Joyant he expressed regret for his own lack of understanding of his son's work and gave Joyant full charge of his son's estate.

Despite its youthful charm and painterly brio, this painting remains essentially an illustrative work by a gifted young man who at this point probably admired the draftsman Constantine Guys more than the painter Manet. It is so far removed from the mean and brilliant works of Lautrec's maturity that the importance of his later training and way of life in Paris can be fully appreciated by the comparison. In the comfort and security of his family surroundings, Lautrec would probably have remained the highly gifted dilettante whose work we see here. When this cheerful painting was done, Lautrec had been crippled for two years. We can therefore suppose that the brutal frankness and cynicism of much of his later work in part reflects Lautrec's objective appraisal of his surroundings, and was not merely a result of his personal misfortunes as many writers would have us believe.

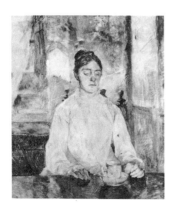

2: COUNTESS DE TOULOUSE-LAUTREC BREAKFASTING AT MALROMÉ (1883)
oil on canvas, 36¼″ x 31½″, Musée Toulouse-Lautrec, Albi

In this portrait of his mother Adèle, Lautrec conveys great tenderness and affection, as he does in all his portraits of her. Painted at age eighteen when he had just entered Cormon's studio, this work shows his early grasp of Impressionism. The shimmering color is like that of Renoir but much lower in key; the whites of the dress, the cup and saucer, and the flowing drapes are a *tour de force* like the snow scenes of Sisley and Monet. In its tenderness and sentiment it is reminiscent of the work of Berthe Morisot. Despite all these allusions to Impressionism, there is a strong linear and realistic quality. The modeling of the figure is quite close to his early drawings done in Bonnat's studio. The handling of the form moves from a realistic treatment of the face and hands outward to an increasingly sketchy and Impressionist approach to the interior and landscape beyond. This combination of interior and exterior space anticipates Bonnard's interiors with windows, and the shallow space and intimate feeling which appear in the work of the Nabis in the next decade.

Lautrec, although distant from his father, was on good terms with his mother throughout his life. He lived with her periodically, lunched with her whenever she was in Paris, and frequently spent summers at Malromé. She provided an escape from the frantic intensity of his bohemian existence and offered a haven of love and security of which he often had need.

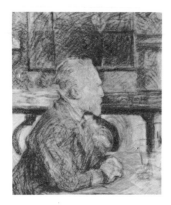

3: PORTRAIT OF VINCENT VAN GOGH (1887), pastel on cardboard
22½″ x 18½″, Vincent van Gogh Foundation, Amsterdam

Lautrec's draftsmanship makes the colored line of pastel a natural medium for him, as the ease and facility of this portrait so amply demonstrate. And yet this is one of the very few works in pastel by Lautrec; the sketch for the *Salon in the Rue des Moulins* (Figure 10) is another. Degas' brilliant use of the medium is quite likely the reason for Lautrec's reluctance to use it, for he was quite sensitive about being compared unfavorably to Degas. On one occasion he had inquired modestly of his friends the Dihaus (whose portraits had also been painted by Degas) whether or not his efforts would bear comparison to those of the master.

Van Gogh is rendered with the heightened color and crosshatching characteristic of Van Gogh's own work. It is not by any means a parody; the sharp linear outlines of the profile provide a dramatic counterpart to the softer crosshatched areas and give to the work a pictorial and psychological tension typical of Lautrec.

The two artists, while too dissimilar for intimacy, were quite friendly during Van Gogh's stay in Paris, before his departure for Arles in 1888. Van Gogh expressed his admiration

for Lautrec's work in letters to his brother Theo, and Theo purchased several of Lautrec's paintings for his employers, the art dealers Boussod and Valadon. After the death of Theo, Lautrec's friend Maurice Joyant became the firm's manager and promoted Lautrec as Theo had tried to promote Vincent's work.

4: LILY GRENIER IN A KIMONO (1888), oil on canvas, 22″ x 18″
Collection of W. S. Paley, New York

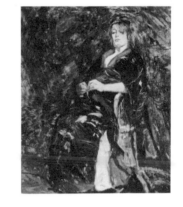

Despite the murkiness of the background and roughness of touch that relate this work to *Fat Maria* and *The Laundress,* there is an interest in color and painterly effects which reappears only in Lautrec's last work, the unfinished portrait of M. Rigaud. Like Whistler's *La Princesse du Pays de la Porcelaine* of 1864 and Monet's *La Japonaise* of 1876, this painting combines an essential realism with Japanese décor. Lautrec has relied less on decorative elements than either of the other artists, although the Japanese kimono gives him an opportunity to play bright areas of color against the free and inventive handling of pattern. In posters and large paintings of later years he mastered these elements in a manner that is at once more truly modern and closer in spirit to Japanese art than Whistler's efforts in this direction.

Lautrec met Lily Grenier through her husband, a fellow student at Cormon's. In 1885 he shared their apartment for a few months and made sketches of them during this stay. He continued his friendship with the Greniers and went on frequent outings with them. In 1888 he painted a small portrait of Grenier and two larger ones of Lily, of which this is one. His friendship with the Greniers provided another indirect contact with Degas. Lily posed for Degas, who occupied a studio in the rear courtyard of 19b rue Fontaine, where the Greniers lived.

5: GUEULE DE BOIS, also called THE MORNING AFTER (1889)
oil on canvas, 18½″ x 21¾″
Fogg Art Museum, Harvard University, Maurice Wertheim Collection

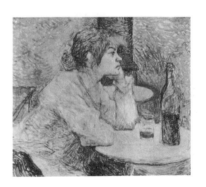

This portrayal of a vacant-eyed alcoholic, posed for by Suzanne Valadon, retains the graphic quality of the two preliminary studies (now in the Albi Museum), but Lautrec has substituted crosshatching for the tinted wash of the drawings. The technique of presenting the profile in strong relief against crosshatching is similar to that in his portrait of Vincent van Gogh (Slide 3). Here, however, shapes are given greater definition and space is more clearly articulated. The linear definition of form and monochromatic quality anticipate the

Blue Period works of Picasso and remind us that Lautrec is one of the great draftsmen of the nineteenth century.

Lautrec is reported to have had a special feeling for this painting. Since it is interesting but hardly outstanding in his *oeuvre,* his attachment was most likely a sentimental one. When Suzanne Valadon posed for this picture she was living in the same building as Lautrec and was caring for her young son, Maurice Utrillo, who was to become the famous artist. Suzanne herself, also a model for Puvis de Chavannes and Renoir, was a gifted painter and later in her life established a considerable reputation. Lautrec was seriously involved with her, but their turbulent affair came to a disastrous and disappointing end when he returned suddenly to his studio and overheard Suzanne's mother berating her for fumbling her opportunity to ensnare him in marriage. He never spoke of Suzanne after this event. This youthful disappointment certainly contributed to his wariness about serious relationships with women.

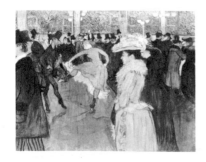

6: THE DANCE AT THE MOULIN ROUGE (1890), oil on canvas
45″ x 59″, Collection of Henry P. McIlhenny, Philadelphia

Joseph Oller's famous music hall, Le Moulin Rouge, provided Lautrec with material for more than thirty works. It was here that Jane Avril, Yvette Guilbert, and La Goulue entertained fashionable crowds. There was a nightly concert of popular songs, but the main attraction was the unpaid performances of the quadrille dancers: Valentin, *Le Désossé* (the Boneless One), and La Goulue are shown performing. Lautrec has included a number of his friends in this canvas, including, from left to right, Maxime Dethomas to the left and behind Valentin, Jane Avril seated with François Gauzi, the photographer Sescau and Maurice Guibert, and Lautrec's white-bearded father Alphonse, on the far right. The lady in the foreground, certainly one of great examples of *la belle peinture* in nineteenth-century art, provides a brilliant counterpoint to the muted tone of the rest of the canvas: To paint an unknown bourgeoise lady with a touch worthy of a Renoir or Velázquez while making his friends and associates dark peripheral figures was typical of Lautrec's perverse humor.

In this painting, one of his most successful, Lautrec has used for the first time a compositional scheme, derived from Degas, that he also used in *The Salon* and other works. Like Degas' *Rehearsal* it has a strong receding foreground plane on the left and friezelike massing of figures in the background. Lautrec has not used this open space as Degas did to provide a sense of stability and repose but rather as a foil for the movements of the dancers. Purchased by Oller, who hung it in the foyer of Le Moulin Rouge, the painting was admired by a generation of artists, including the Fauve painter Valtat and Lautrec's friend Louis Anquetin, who later produced their own versions of the work.

7: MADEMOISELLE DIHAU AT THE PIANO (1890)
oil on cardboard, 26¾″ x 19¼″, Musée Toulouse-Lautrec, Albi

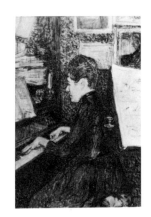

This portrait of Marie Dihau seated at the piano, surrounded by books, music, and paintings, is a testament to the cultural activities of the Dihau family, the cousins through whom Lautrec met his *leiber Meister,* Degas. Degas had made portraits of Mlle. Dihau, and the bassoonist who figures so importantly in the composition *Orchestra of the Paris Opera* is Désiré Dihau.

The closeness of texture and all-over tonality of this painting contribute a feeling of warmth and intimacy, also characteristic of interiors by Bonnard and Vuillard. The sitter's hands poised angularly over the keyboard and the sharp outline of her intense profile contrast vividly with the general softness of her dress and the interior. The books, paintings, and sheet music provide the only other contrast and define the close interior space. The white sheet music on the stand lends an awkward immediacy to the scene and serves to separate, by overlapping planes, the figure of Mlle. Dihau from the portrait on the wall which echoes her pose. This painting, so realistic in its general aspects, is full of abstract devices, such as the emphasis on the planar characteristics of the piano keyboard, and the formal rather than representational relationships of pictures and sheet music. Lautrec later used these abstract devices with greater boldness and clarity. Their importance for modern artists can be seen in such works as Matisse's *Red Studio,* where paintings and objects in a room are used to define a purely pictorial space in a manner not unlike Lautrec's somewhat less realized efforts here. Vincent van Gogh wrote to his brother Theo of his admiration for this work, so similar to his own *Portrait of Mlle. Gachet at the Piano.*

8: AT THE NOUVEAU CIRQUE: FIVE STUFFED SHIRTS (1891)
watercolor on paper on canvas
23¾″ x 16¾″, Philadelphia Museum of Art

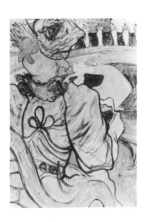

Generally believed to be a preparatory sketch for a poster, some writers have suggested that *Nouveau Cirque* is a design for stained glass. Its exuberant Art Nouveau rhythms and translucent brilliance would make a realization in stained glass particularly striking. Black linear elements appear throughout the composition in such a way as to suggest a possible distribution of lead to hold the segments of stained glass together. Regardless of its intended function, this sketch is a fully realized work.

The serpentine forms on which this composition is based, seen also in the work of Munch, Gauguin, and many other artists of the period, are handled by Lautrec with a robustness and energy differing markedly from the usual precious aestheticism of Art Nouveau. The

corseted extravagance of the lady's costume compared to the unconstrained simplicity of the acrobatic dancer's flowing robe emphasizes Lautrec's sardonic comment by a contrast of form.

This work anticipates the composition of *Jane Avril at the Jardin de Paris* of 1893 (Figure 4), where the performer is framed by the dramatic curve of the cello, which creates a tense focus on her movements in the compressed but open space which remains. Note has already been taken of the compositional similarity to E. L. Kirchner's *Circus Rider* (Figure 16).

The circus theme reappears in 1899, in work done by Lautrec during his convalescence in a private asylum after a severe mental collapse. The series of brilliant drawings of circus performers produced from memory helped convince his doctors that he was sufficiently recovered from his aberrations to be released.

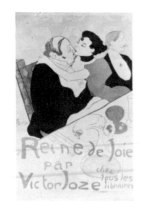

9: REINE DE JOIE (1892), color lithograph
51¼" x 35", Musée Toulouse-Lautrec, Albi

Lautrec began making posters in 1891 and raised this relatively new medium to a level of excellence that set the standard for twentieth-century designers. *Reine de Joie* is the fourth of his thirty posters. The first was *La Goulue au Moulin Rouge,* the preparatory sketch of which is shown in (Figure 11). Manet and Daumier had already made posters in black and white, and Jules Chéret had created the color poster, which enjoyed so much popularity in the 1890s (Figure 2). Nabis and Art Nouveau artists also contributed to the development of this medium, but only Lautrec approached the poster with the same seriousness and enthusiasm that he applied to his work in other media. That Lautrec was one of the first to follow the British designer William Morris in breaking down the traditional barrier between "fine art" and craft is another aspect of his modernity.

Lautrec has made wonderful use of yellow, red, and black to achieve a fullness of color design. The olive-green lettering forms a visual screen that is balanced by the pattern of the two yellows in the background; the black is used only for mass, while the linear detail is either red or green. The figures of the aging roué and his "queen of joy" girl friend, delineated with red and green lines, form an intricate pattern. In the chair and the hair of the bored young man on the right, flat areas are lightened by the use of a spattered ink effect, which Lautrec obtained by using tusche and a toothbrush. The drawing of the still life anticipates Matisse's simplification of line to articulate form. The daring juxtaposition of pure colors and the use of pattern and linear detail, all harmoniously working to a single visual effect, bear witness to Lautrec's genius in the medium of the poster.

10: THE ENGLISHMAN AT THE MOULIN ROUGE (1892)
color lithograph, 18½″ x 14½″, Musée Toulouse-Lautrec, Albi

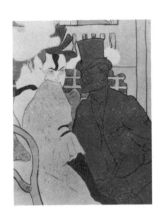

The theme of this lithograph, a middle-aged man waiting for or selecting a young girl, appears frequently in Lautrec's work. There is a much more complex medium of exchange than money; it is an agreement between lust and greed, middle class and declassé, and jaundiced satiety and youthful energy, in a complex series of inversions and symbiotic relationships of youth and age, masculinity and femininity. This work shows the opposite pole of Lautrec's adoration of theatrical stars like Yvette Guilbert, Marcelle Lender, or of women of his own class whom he admired only from a distance. Lautrec, usually so discerning and subtle, in this painting expresses an attitude toward sex that is typically Victorian. When dealing with men or women separately he is much more sympathetic, expressing and accepting nuances and contradictions of character without bitterness and with real understanding.

Lautrec's interest in certain objects for their quality as abstract form is clearly demonstrated here by his use of motifs which appear in later works. The fragmented chair is repeated in *Maxime Dethomas at the Opera Ball* (Slide 19); the large hats in *La Troupe de Mlle. Eglantine* (Slide 17) are variations on the large light hat in this work, and the long black glove later becomes Yvette Guilbert's trademark (Slide 16). The totally purple figure of the Englishman, so economically indicated against the complementary orange, shows Lautrec's mastery of line and mass and further demonstrates his interest in abstract relationships.

The sketch for this work, in the Metropolitan Museum, New York, shows the influence of Degas. The lithograph departs from the linear color effects and generally muted quality of oil on cardboard and moves to a bolder, more individual, more truly modern manner.

11: LOÏE FULLER AT THE FOLIES BERGÈRE (1893)
color lithograph, 13⅓″ x 10¼″, Musée Toulouse-Lautrec, Albi

A truly seminal work can never be completely successful and this is certainly the case with Lautrec's lithograph of Loïe Fuller doing her fantastic dance at the Folies Bergère. In this single incomplete work Lautrec has anticipated important movements in twentieth-century art. The portrayal of continuous movement, first attempted by Lautrec in his paintings of La Goulue, Jane Avril, and Loïe Fuller, became a central theme for the Futurists, using cubist analysis of form, some twenty years later. The Abstract Expressionist feeling for gesture and material is also anticipated: the gesture and flow of tusche remind one of artists like Hans Hofmann in his more open work; the gold flecks are like the aluminum paint in Jackson Pollock's works of 1948 to 1951. Lautrec's feeling for material and plastic

invention are well in advance of his time, but it is his ambition that is truly revolutionary. While Degas wanted to catch the interesting and eccentric form of the dancers he painted, Lautrec was after the movement itself. Degas is still part of the nineteenth century, but Lautrec belongs to the twentieth.

The Illinois-born Loïe Fuller was as much in advance of her time as Lautrec himself. Her dances, such as the serpentine depicted in this lithograph, featured electric colored lighting and the transparent effect of gauzy material. Updating Salome and anticipating Sally Rand and her fan dance, she created the first light show. Lautrec, like Loïe Fuller, combined several effects in this work, in which colored washes applied with cotton wool and flecks of powdered gold have been added to the black ink print.

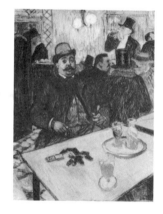

12: MONSIEUR BOILEAU IN A CAFE (1893), gouache on canvas
31½″ x 25⅝″, Cleveland Museum of Art, Hinman B. Hurlbut Collection

Despite the dedication in the upper-left-hand corner, there is nothing personal in this portrait, and Lautrec's handling of M. Boileau is not very sympathetic. He is represented here as the personification of a jaded, overfed businessman on the town. In the masculine atmosphere of a crowded bar, the men huddled at the table behind him are intent on card playing or conversation. The standing bearded figure at the bar (Lautrec's father Alphonse) emphasizes M. Boileau's isolation. There he sits all alone—stuffed, sated with absinthe, bored with his dominoes, cigarette in one hand, cane in the other in a gesture which suggests his dissatisfaction with the all too turgid maleness of the cafe.

This completely masculine picture is rare in Lautrec's work and the composition reinforces our reading of M. Boileau's character and situation. Two tables make a powerful diagonal thrust. Unlike Degas' *Absinthe* (Figure 13), where the same device is used to create a very clear spatial ambiance, Lautrec tilts the table tops, the floor plane, and the bar behind to add to the discomfiture of M. Boileau. By contrast, the figure of Lautrec's father standing in the rear exists in the comfortable space provided by the seated figures who surround him. Boileau is an *arriviste* uncomfortable with his pleasures, while the old aristocrat takes his with perfect ease.

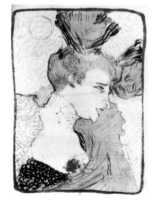

13: THE ACTRESS MARCELLE LENDER (1895), color lithograph
12″ x 8¾″, Bibliothèque Nationale, Paris

Marcelle Lender was the subject of a series of lithographs and drawings from 1893 to 1896. In a work of 1894 she is represented in a scene from "Madame Satan," a play pro-

duced at the Théâtre des Variétés. In 1895, the year this work was made, Lautrec did a series of eight lithographs of Lender. She is the central figure in one of Lautrec's largest paintings *Lender Dansant le Pas du Bolero dans Chilpéric,* a scene from an operetta by Hervé, a popular composer of the day.

Lautrec admired Lender in the same way he admired Yvette Guilbert, Jane Avril, Aristide Bruant, and the other stage personalities he portrayed. There are no personal or psychological observations, only the projection of a dramatic stage personality. She is the object and subject of the stage footlighting, which illuminates her face and puts her forehead in shadow.

Lautrec synthesizes in this lithograph several tendencies that are present in the work of many artists of the 1890s. The free, open sketchiness is characteristic of much later impressionistic drawing. The ruff around her neck, the contours of her hair, face, and ribbons are delineated with great fluency and freedom. The opposition of various patterns in her costume and hair is characteristic of much of the art of the Nabis. The influence of Japanese art can be seen in the bold use of red and green areas and the off-center composition they create. Lautrec's monogram, like Whistler's butterfly, imitates the stamp with which Japanese artists signed their woodcuts.

14: GABRIEL TAPIÉ DE CÉLEYRAN (1894), oil on canvas
43¼" x 22", Musée Toulouse-Lautrec, Albi

Lautrec's portrait of his first cousin Gabriel shows that aspect of his art which places him between realism and expressionism. This pensive, awkward, lumbering man, who was Lautrec's childhood playmate and almost inseparable adult companion, is depicted in one of Lautrec's most sympathetic portraits which, with a simpler background, would have been a penetrating psychological study.

Although broadly painted, there is little of caricature or role playing in this portrayal of Gabriel. This realistic approach to the figure contrasts with the setting—the corridor of the Comédie Française. The red of the rug is most likely a realistic detail; however, against the strange figures in the background, reminiscent of the work of Edvard Munch, and the red reflection in the mirror on the left, it takes on a sinister aspect, bathing the scene in a macabre light from which the figure of Gabriel is isolated by two blue vertical stripes and the darker blue of his suit.

Gabriel, "the doctor" as he was called, figures in a number of other paintings. He is in the background, along with Lautrec, in *Au Moulin Rouge* (Chicago Art Institute), and one of Lautrec's last paintings, *An Examination at the Faculty of Medicine of* 1901 (Albi) shows him taking his doctoral examination.

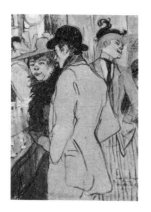

15: ALFRED LA GUIGNE (1894), oil on cardboard, 33½″ x 24¾″
National Gallery of Art, Washington, D. C., Chester Dale Collection

Alfred La Guigne is the name of a character in a novel by Lautrec's friend Oscar Méténier, to whom this painting is dedicated. La Guigne, the figure in the bowler hat with his hands in his pockets, is shown at the bar of the Moulin de la Galette with two women, suggesting some unsavory *ménage à trois.* Although almost forming a single mass, the three figures seem isolated from one another. Alfred is self-contained, glancing only at his drink; the two women look about in opposite directions with the glances of their trade. Lautrec has used the natural color of the cardboard for La Guigne's coat and face, the skirt of the masculine younger woman, the highlights on the bar, and to indicate the wall in the background. It is a brilliant mixture of linear and painterly touches. The openness of the right-hand side, where the figures are indicated by a few deft strokes of Lautrec's brush, is balanced by the crowded, more colorful, left-hand part of the canvas, providing simultaneously a sense of stability and of movement. The brightness of the color in this work only serves to emphasize the tinsel drabness of these underworld types.

This is the only illustration which Lautrec completed for Méténier's book. It is unfortunate that their collaboration on this project faltered because the novel about a young hoodlum set against the scene of Parisian bohemian cafes was a natural subject for Lautrec.

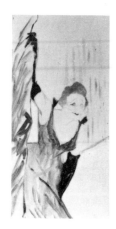

16: YVETTE GUILBERT TAKING A CURTAIN CALL (1894)
photographic enlargement of lithograph heightened by colors of spirit
18⅞″ x 9⅞″, Musée Toulouse-Lautrec, Albi

Lautrec's fascination with the cafe star Yvette Guilbert is easy enough to understand. She had red hair, a mobile expressive face and extravagant gestures, and was a brilliant part of the cafe life to which Lautrec gave so much attention. Unlike many of the marginal entertainers whose careers Lautrec made important, she had a long and successful career. Yvette performed in America in 1895 and ended her career in 1927 with her memoirs, *Chanson de ma vie,* which has many references to her relationship with Lautrec. Although they were friends, Lautrec never made a personal portrait of her. Off stage Yvette Guilbert was a very attractive woman, but Lautrec preferred her stage appearance: the long black gloves, the low-cut dress, and makeup which made her features sharper than they were. Dramatic appearance always interested Lautrec more than conventional beauty.

This work, a photographic enlargement of a lithograph which Lautrec painted with turpentine washes, must be the first combination of photography and painting by an important artist—a technique which still appears revolutionary in the work of Pop artists of this decade. Photography here is merely the tool for transferring the brilliant work of

Lautrec's hand. It retains all the freshness of a sketch plus the vividness of color washes. This is the last of a series of sixteen lithographs published in 1894 as an album on Yvette Guilbert, with a text by Gustave Geffroy. Though reported at first to have been so furious with Lautrec's pictorial treatment of her that, encouraged by her mother, Yvette considered a libel suit; the laudatory articles which appeared (including one by Clémenceau in *La Justice*) must have mollified her, for she wrote Lautrec a very cordial letter expressing her delight with the drawings.

17: LA TROUPE DE MADEMOISELLE EGLANTINE (1896)
color lithograph, 24″ x 31½″, Musée Toulouse-Lautrec, Albi

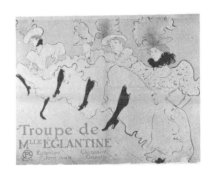

Lautrec's command of abstract design is clearly demonstrated in this poster. The yellow, blue, and red inks are used purely, without mixing, to obtain maximum color contrast. The changes in tone are arrived at by varying the density of application rather than by using green and orange mixes, an easier and less imaginative solution. The yellows, moving from the large dots of the stage front to the smaller closer ones of the floor to the solid yellow of the background, provide a sense of space without disturbing the flatness of the poster surface. This effect is also enhanced by the diminishing scale of the hats of the three dancers on the right. The figure of Jane Avril is brought forward by a change of scale in her blue hat and a change in interval of the yellow background. The poster is made lively through repetition and variation; everything is the same and everything is different, and each form functions in a complex duality. By their vertical thrust, the blue hats stabilize the composition despite the fact that their diminishing scale creates spatial tension. The horizontal direction of the red print and yellow background sets the limits of the forward thrust of the diagonal line of dancers, who are at once a large simple mass and four distinct personalities, namely: Jane Avril, Cleopatra, Eglantine, and Gazelle. The stockinged legs in brownish-purple show a variation of form and gesture which belies a seemingly casual rendering. It is this economy of means and richness of effect which permits us to speak of the greatness of Lautrec's poster art.

18: WOMAN AT HER TOILETTE (1896)
oil on canvas, 25½″ x 20⅞″, Louvre, Paris

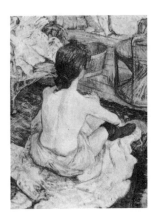

The subject is one Degas had treated extensively, a half-clothed woman at her bath. Though exploiting the cut-off composition derived from contemporary photographs, and the sense of intimacy achieved through eccentric views of the subject, devices favored by Degas,

Lautrec presents us here with a uniquely composed, masterful handling of this theme. The receding plane of the floor is punctuated by a series of broken circles: the spread of the model's petticoat echoes the arc of the wicker furniture, the broken curve of the tub repeats, in a minor key, the circle formed by the chairs and the model, who seems as immobile as the furniture. At the center of this powerfully established plastic organization is the figure of the girl, seen from the back as an anonymous but unique column-like element in the structure.

This painting revolves around two of Lautrec's obsessions, red hair and backs. Lautrec painted redheads whenever he had a choice of hair color. Romain Coolus, one of Lautrec's friends from the *Revue Blanche* circle, tells of Lautrec's dragging him to the theater twenty times in the winter of 1895 and 1896 to sit through the operetta "Chilpéric" for the sole purpose of admiring Marcelle Lender's "splendid" back.

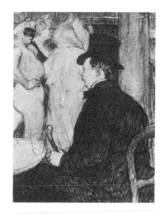

19: MAXIME DETHOMAS AT THE OPERA BALL (1896)
cardboard, 27½″ x 20¾″
National Gallery of Art, Washington, D. C., Chester Dale Collection

Maxime Dethomas (1867-1929) was a draftsman and painter who studied at the Ecole des Arts Décoratifs and with Lautrec's early master, Bonnat. A giant, gentle, soft-spoken man, he was Lautrec's friend from the early 1890s until Lautrec's death. Dethomas's portrait of Lautrec appears on the frontispiece.

Lautrec has emphasized the size of Dethomas, a portly man six and a half feet tall, by crowding him uncomfortably at a table too small for his knees, in a chair which doesn't hold him. The instability of the furniture emphasizes his impassive bulk, and the sobriety of his dress against the frivolous pink of the masked figure plays up the impropriety of the situation. The imaginary setting bears no resemblance to the top-hatted elegance of the actual Opera Ball, and the reference is, in fact, ironic. Dethomas plays the role of the slightly bored, jaundiced gentleman choosing, or awaiting, the pleasure he has purchased. This is an important theme in Lautrec's theater of absurdities and is repeated in the *Englishman at the Moulin Rouge* (Slide 10), *Monsieur Delaporte* (Ny Carlsberg Glyptothek, Copenhagen), and *A Passing Fancy*, a lithograph of 1896.

Lautrec's view on love is illustrated in the following passage from Yvette Guilbert's memoirs *La Chanson de ma Vie,* "If you sang of a desire said the artist, people would understand, and if you sang of its manifestation they would be amused . . . but love, my poor Yvette, love does not exist.

And the heart, Lautrec, what do you make of that?

The heart, what has that to do with love?" The views Lautrec expressed here indicate the autobiographical nature of this theme.

46

20: PORTRAIT OF PAUL LECLERCQ (1897)

oil on canvas, 21¼" x 25¼", Louvre, Paris

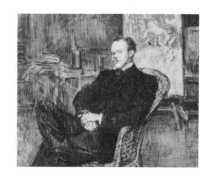

A number of writers have noted Lautrec's admiration for the American painter and engraver James McNeill Whistler. One can see in this portrait of Paul Leclercq a feeling for arrangement, however superficial, that is similar to Whistler's portraits of his mother and of Thomas Carlyle. Despite very basic differences in technique and realization, the two artists share a common approach to painting and a significant influence from Japanese prints.

Both flamboyant personalities, Whistler and Lautrec worked with a dash and bravura that is more important than similarities of form. Each sacrificed nicety of detail for better organization of the whole canvas. Whistler's musical titles and suppression of detail bear witness to this interest in total form; Lautrec once told Yvette Guilbert, in response to her objections about his treatment of her face, "I totalize you." Whistler believed a painting should be finished "in an afternoon" no matter how much time had been devoted to it previously; Lautrec's approach to portraiture was quite similar. Leclercq and others have written about their experiences as models for Lautrec, and agree that despite numerous sittings and considerable involvement the actual execution was rapid. As is true of most of Lautrec's sympathetic portraits, the clarity of the face and hands in this painting contrasts sharply with the sketchiness of the studio interior.

Leclercq, founder of *La Revue Blanche,* was a close personal friend and author of a book of memoirs called *Autour de Toulouse-Lautrec.* Lautrec designed a book jacket for his novel, *L'Etoile Rouge,* published in 1898.